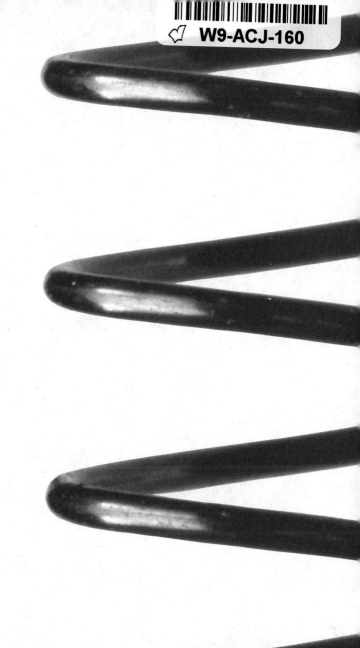

Everyday Mysteries

Jerome Wexler

SCHOLASTIC INC.
New York Toronto London Auckland Sydney
Mexico City New Delhi Hong Kong Buenos Aires

To my editor, Donna Brooks, and the crew at Dutton Children's Books

Designed by Semadar Megged.

Copyright © 1995 by Jerome Wexler.
All rights reserved. Published by Scholastic Inc., 557 Broadway, New York, NY 10012, by arrangement with Penguin Books USA Inc.
Printed in the U.S.A.

ISBN 0-439-86635-9

SCHOLASTIC and associated logos and designs are trademarks and/or registered trademarks of Scholastic Inc.

3 4 5 6 7 8 9 10 40 14 13 12 11

spring

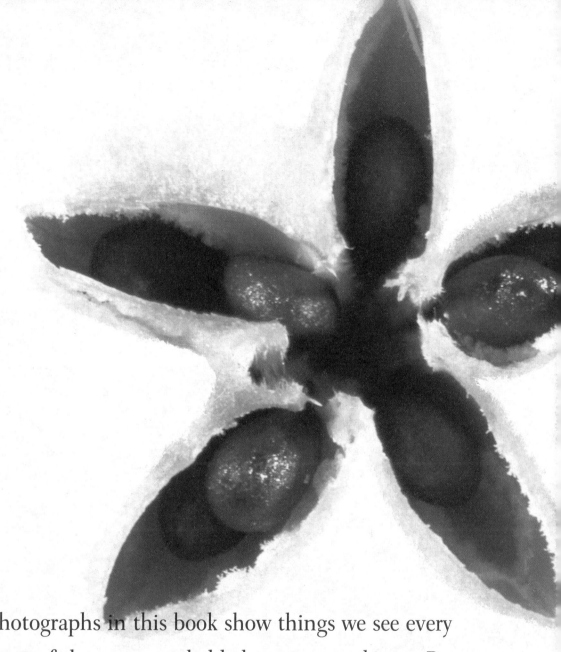

The photographs in this book show things we see every day. Many of them you probably have in your home. But the photos show these objects in new ways. They show parts and surfaces, edges and cross sections, and silhouettes, too. You may not know exactly what you are seeing —or you may guess right away. If you do guess correctly, the photographs may allow you to see (and remember)

details or shapes or patterns. The photographs can make you think. Looking at objects close up or in an unusual light or from a different point of view can produce surprises. Perhaps you will find your own everyday mysteries in the world around you.

Have fun!

The answers to the mystery photos in this book can be found at the end of each section.

Part of the Whole

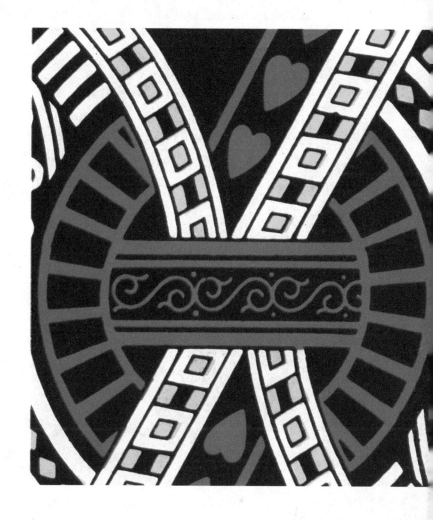

Seeing only part of an object can be mysterious. The part reminds us of something—but what, exactly? Enlarged in a photograph, the part may look even more unusual. Or you may recognize it easily. The part, by itself, emphasizes something about the structure of the object or the way it works.

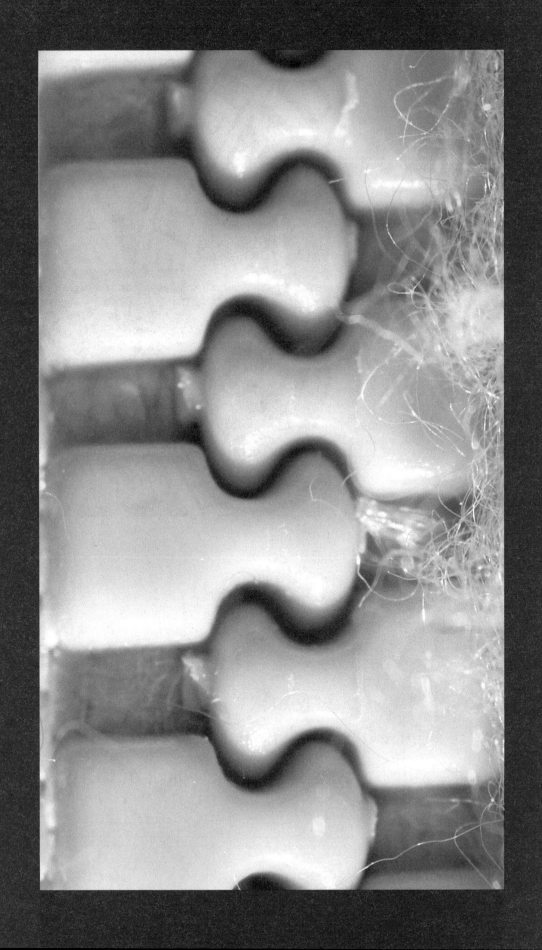

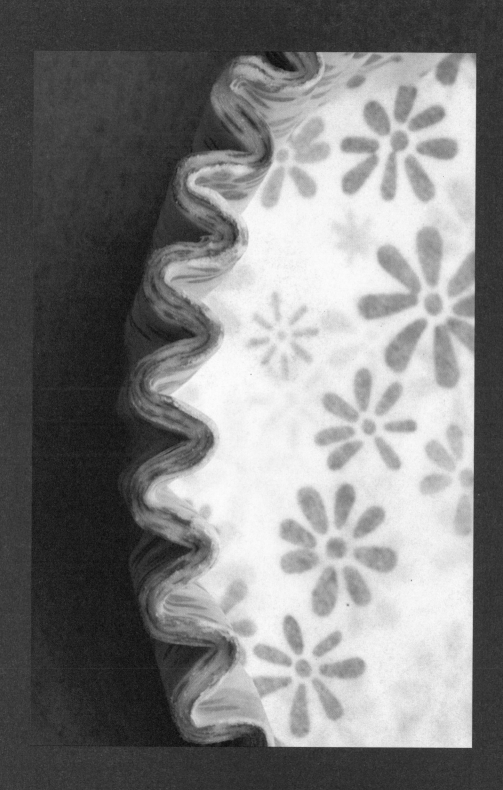

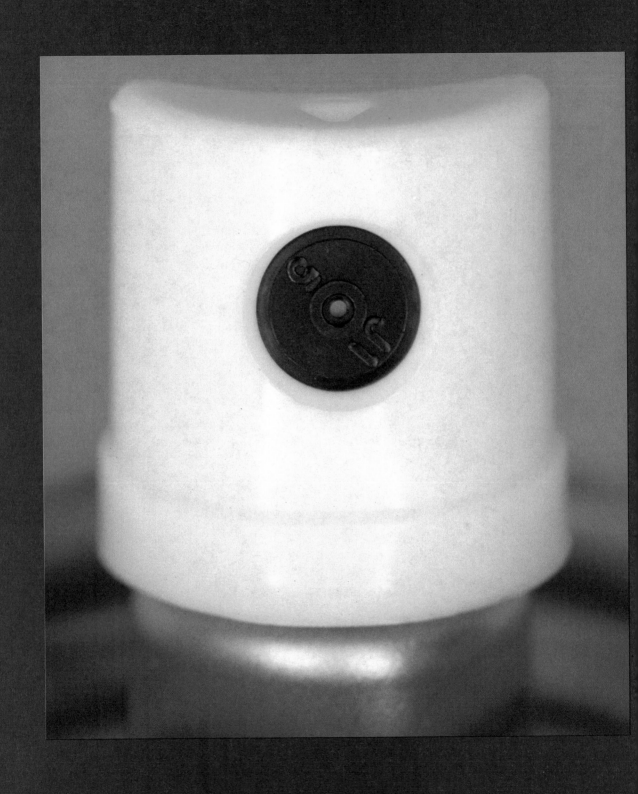

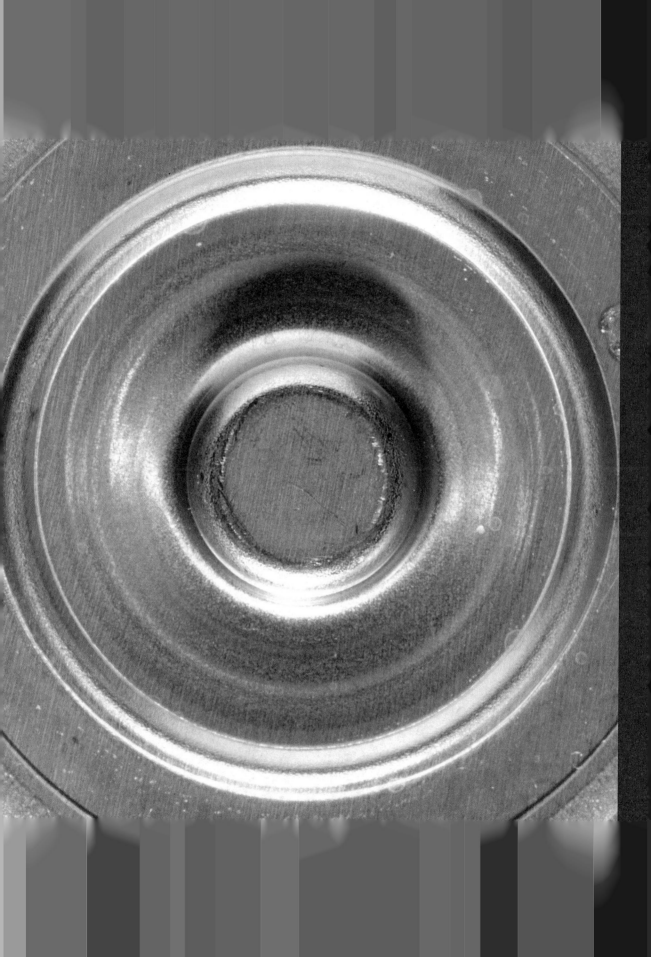

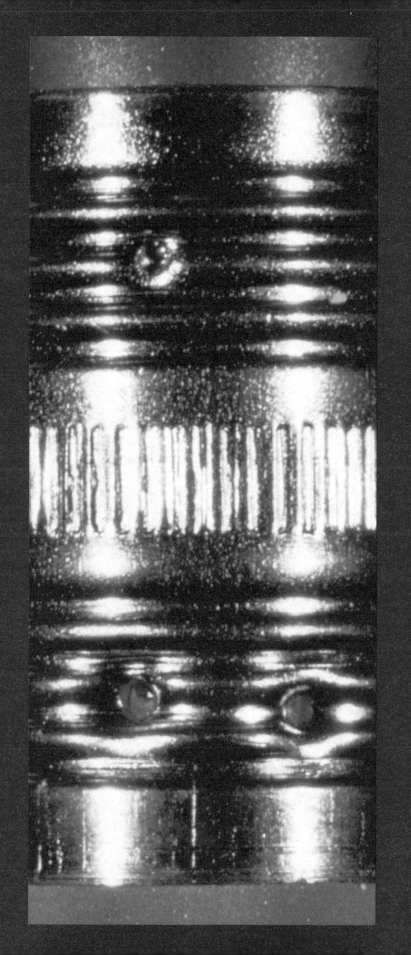

playing card

zipper

cupcake liners

spray can

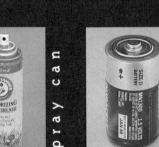

battery

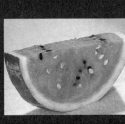

watermelon

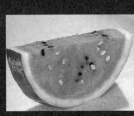

pencil

Surfaces Close Up

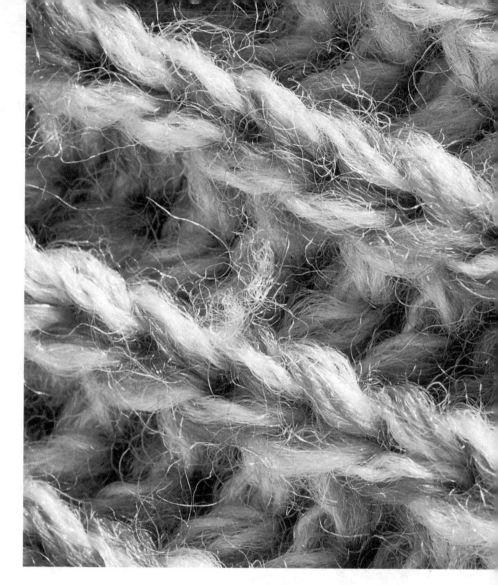

The surface of an object is what we usually see and touch. The lens of a camera, held close to an object, magnifies its surface. We observe details, patterns, and textures in a more vivid way. If we were to look at surfaces under a microscope, at still higher and higher magnifications, what we see would keep changing. We might see things we hadn't known existed.

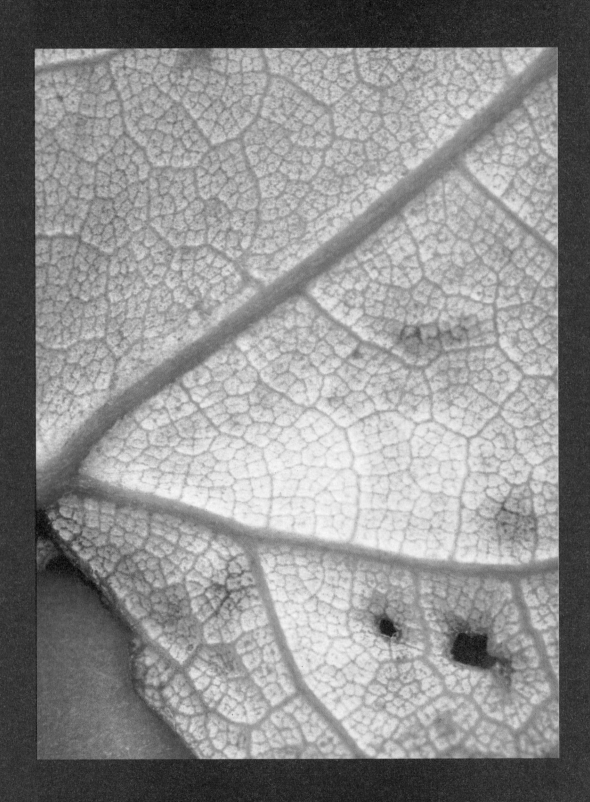

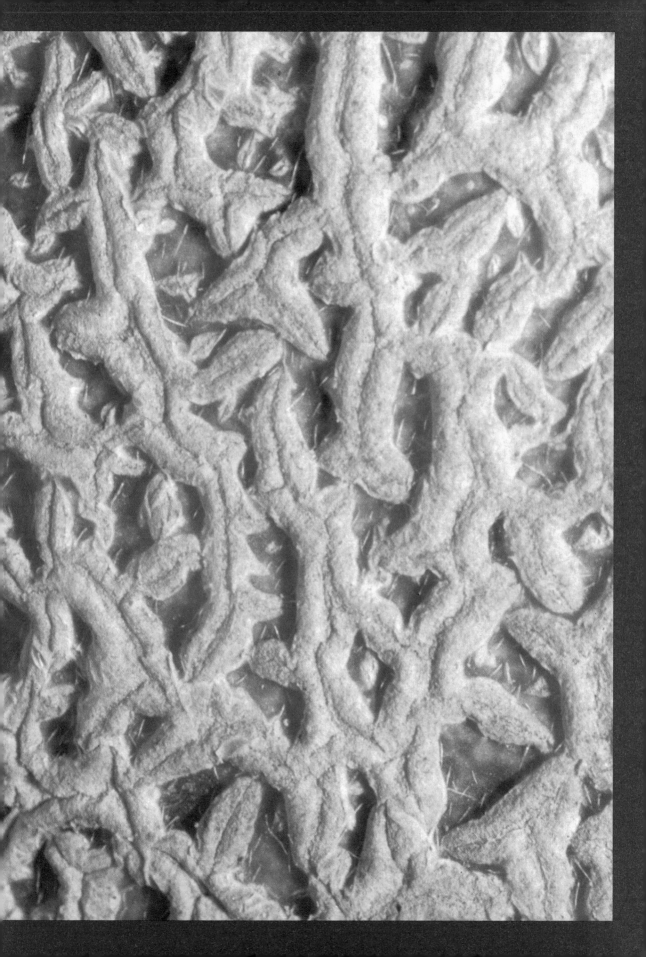

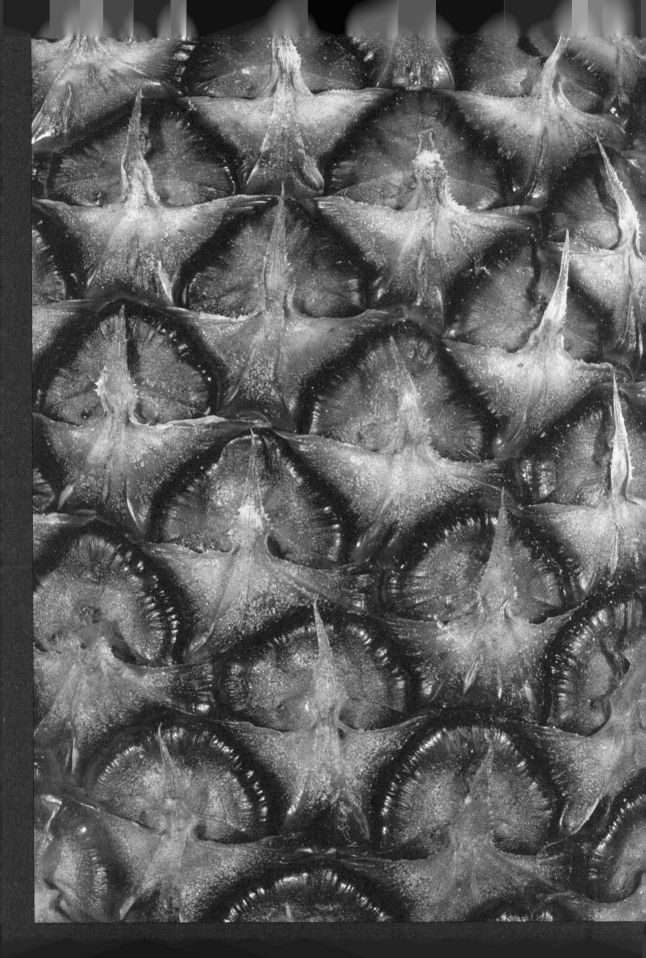

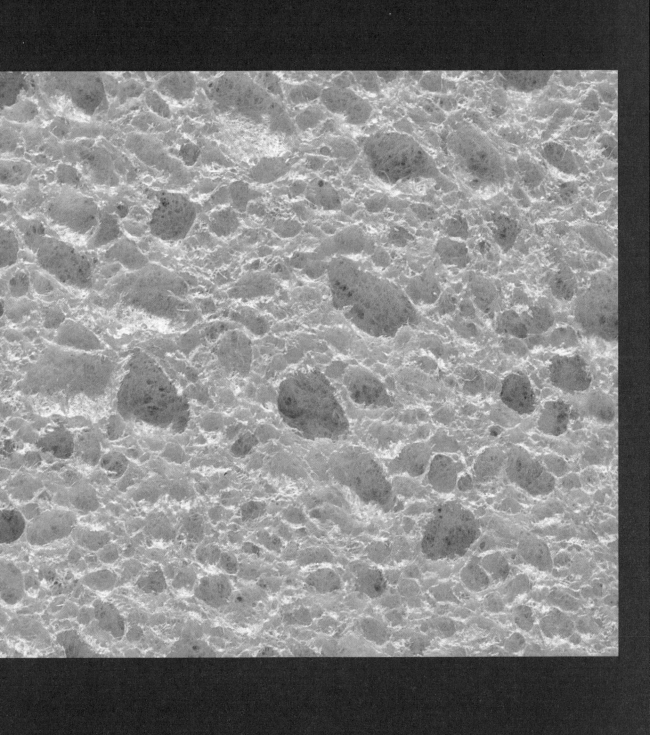

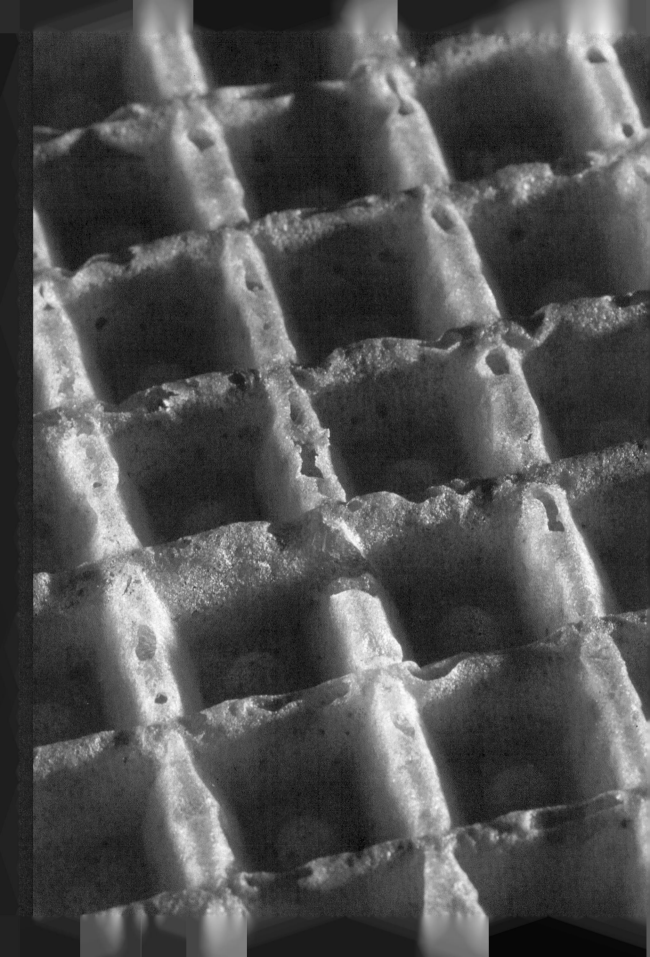

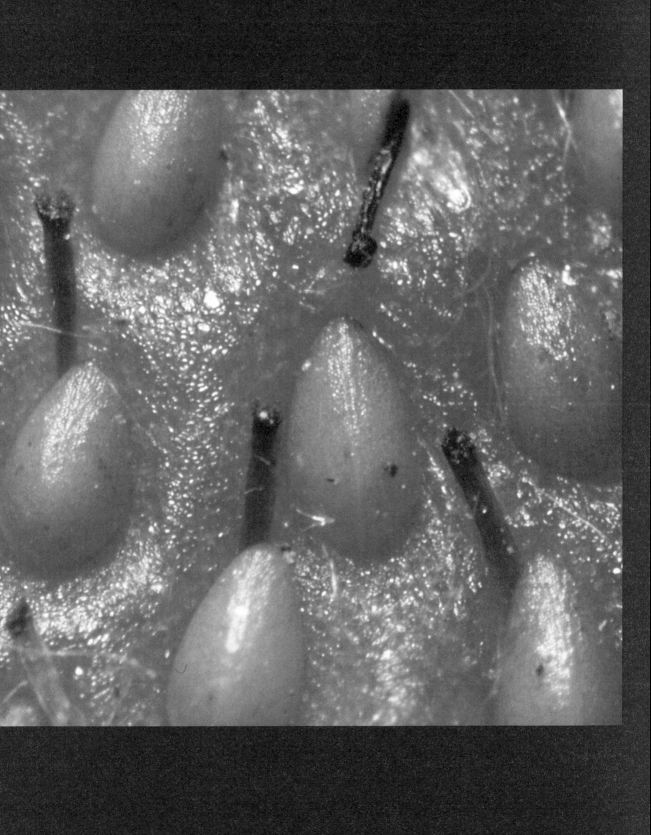

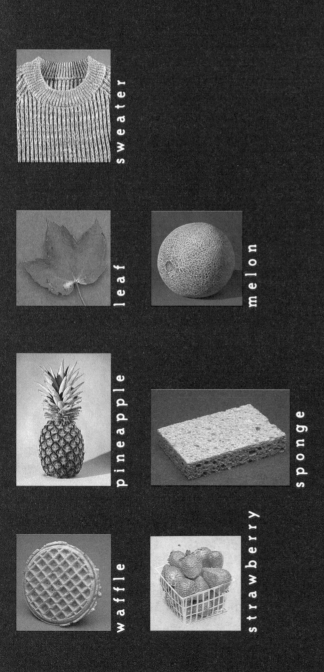

sweater

leaf

melon

pineapple

sponge

waffle

strawberry

Cross sections

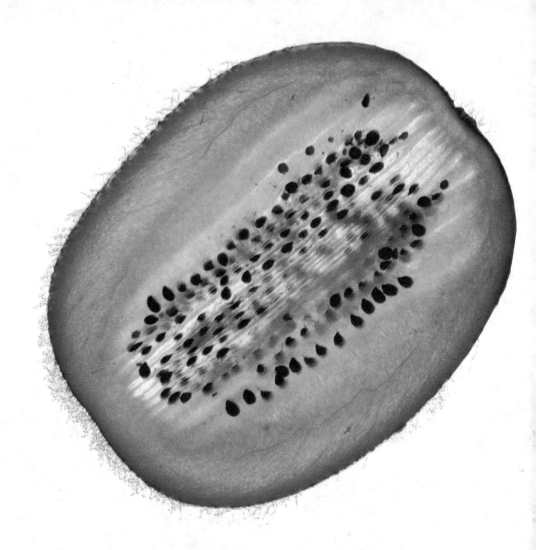

Cutting through the center of an object makes a cross section. This allows us to see what the inside of an object looks like and how it is organized. In preparing food, we often cut cross sections. A lemon slice is a cross section, for instance. So is a slice of bread. And some objects, open at their ends—like a roll of tinfoil—allow us a cross-sectional view.

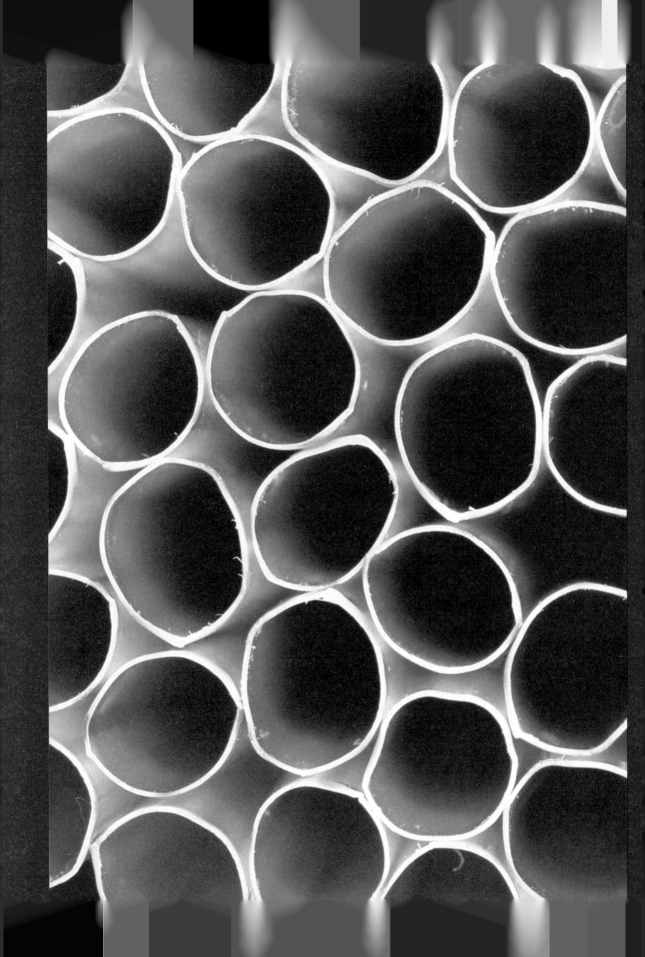

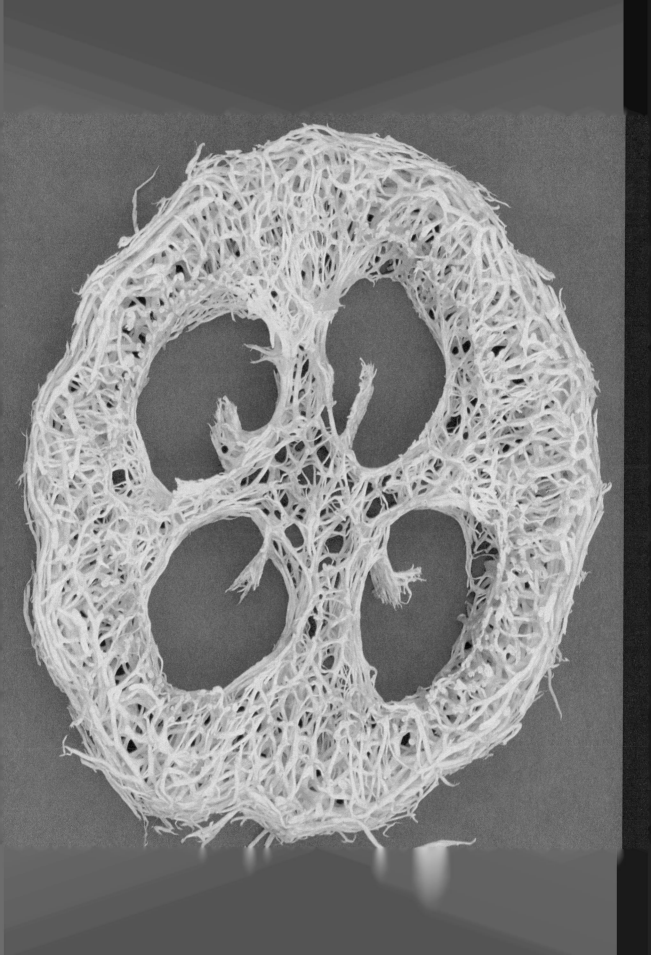

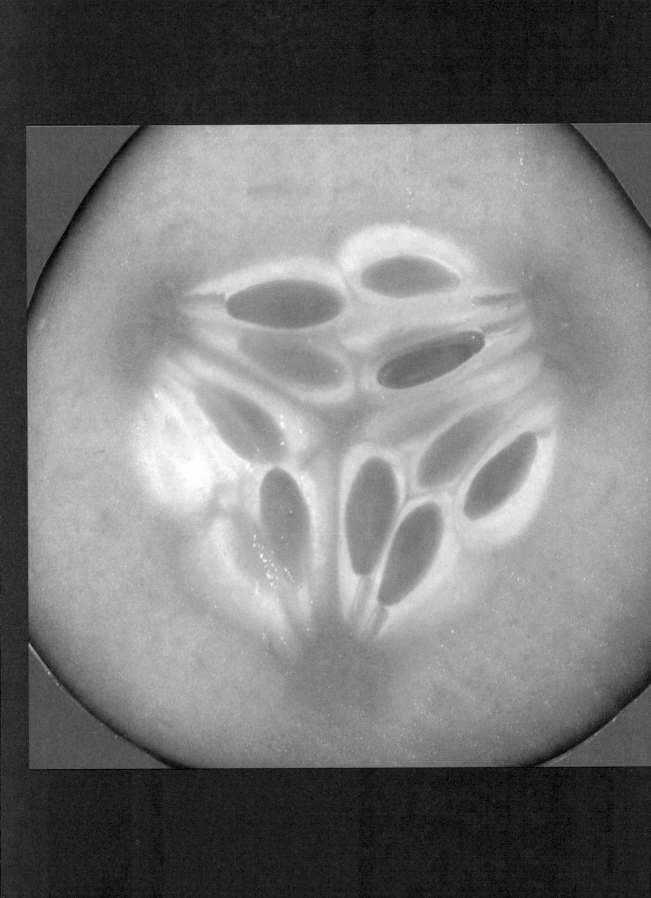

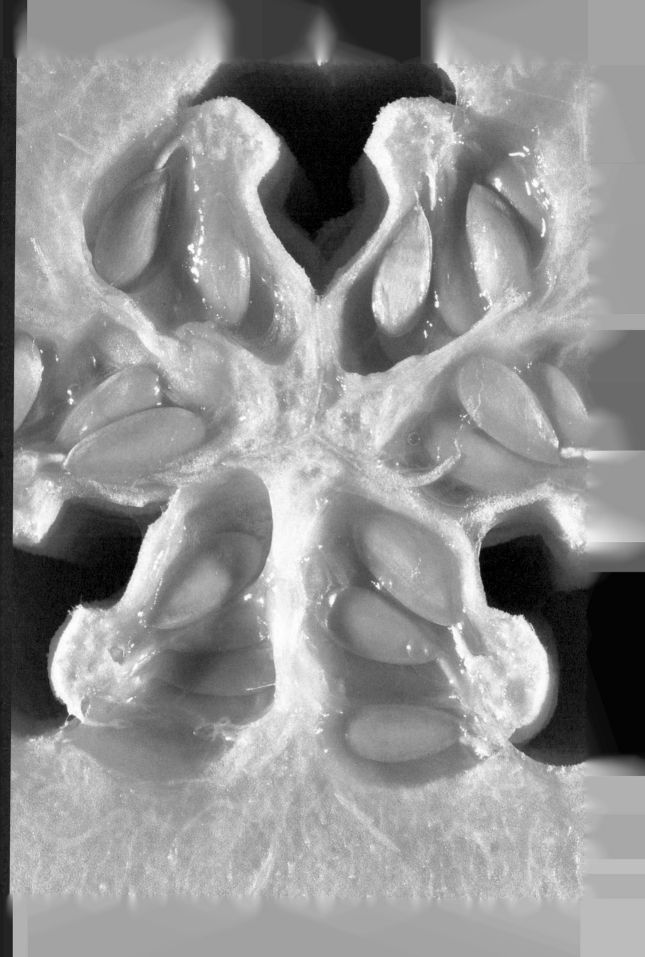

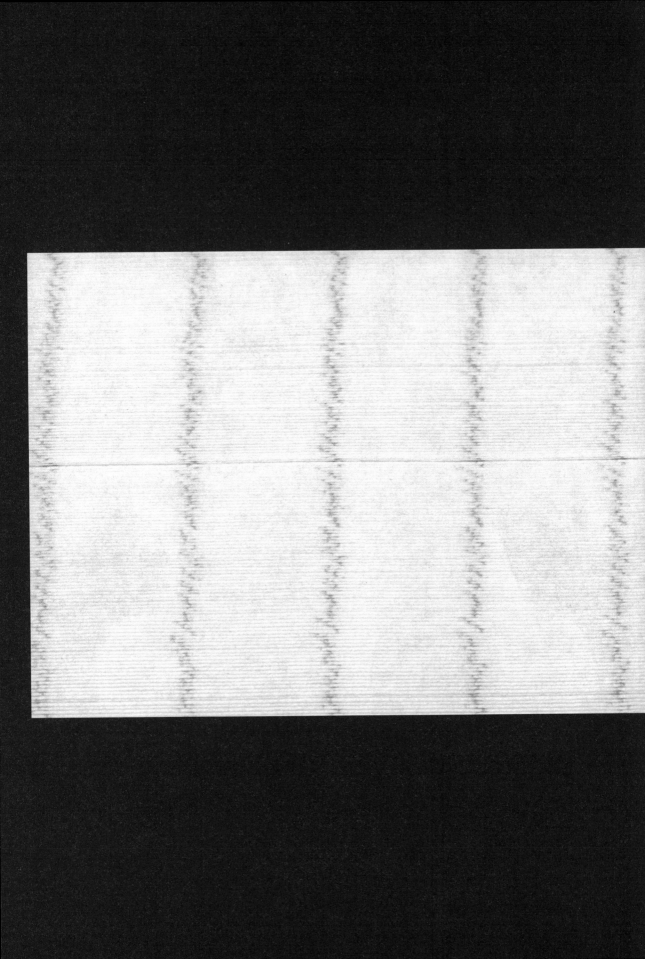

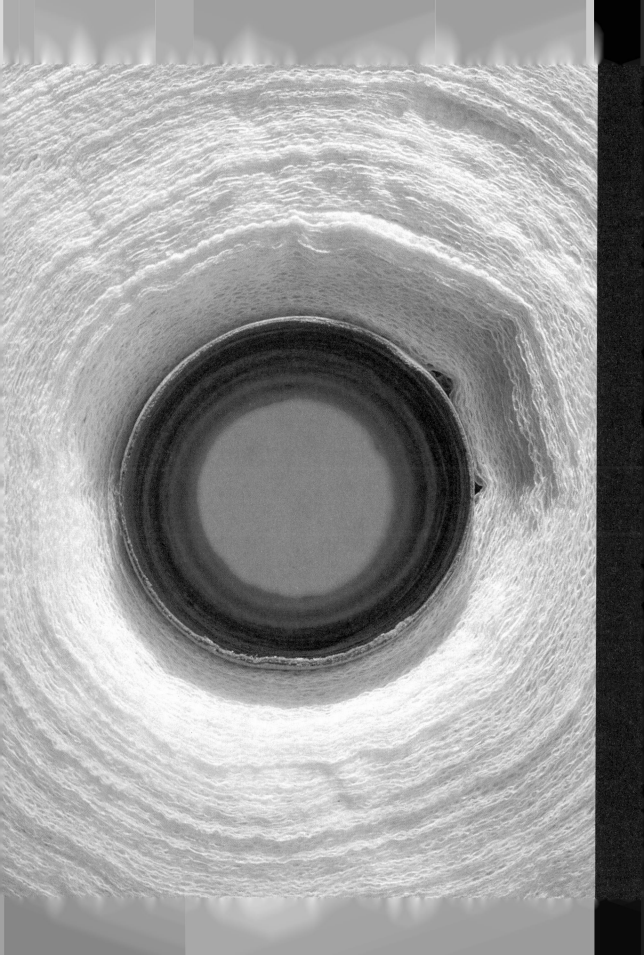

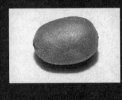 kiwi

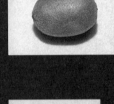 straws

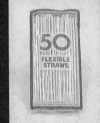 loofah

 cucumber

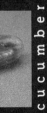 melon

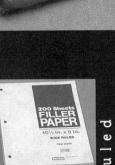 ruled paper

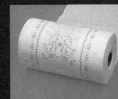 paper towels

silhouettes

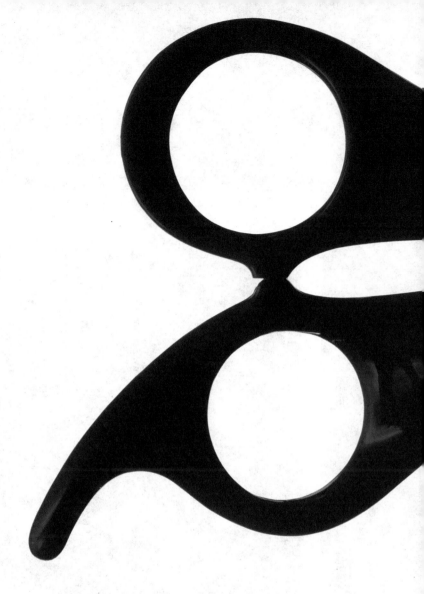

Silhouettes seem mysterious because they show us only the outline of a shape, completely filled in. You can draw a silhouette. Or you can cut one out of paper. Light can make a silhouette, too—shadows are silhouettes. Some objects are so familiar to us that we can quickly identify their silhouettes. A few of the silhouettes here are a little harder to figure out because they represent not the whole object but only part of it.

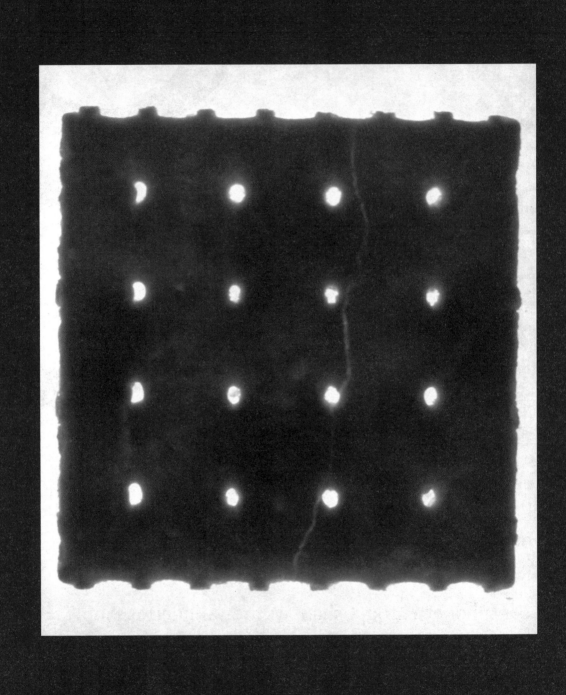

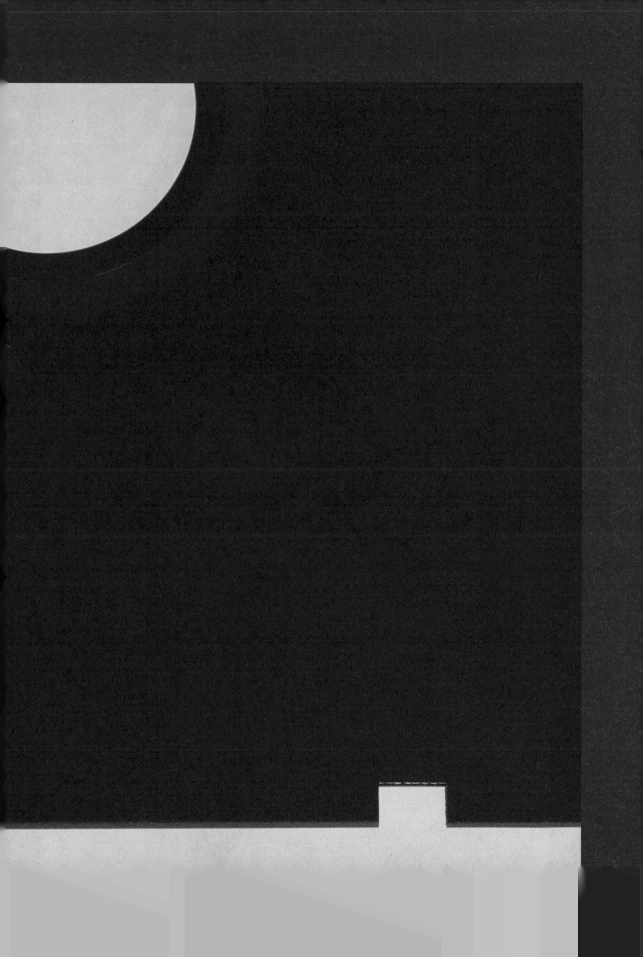

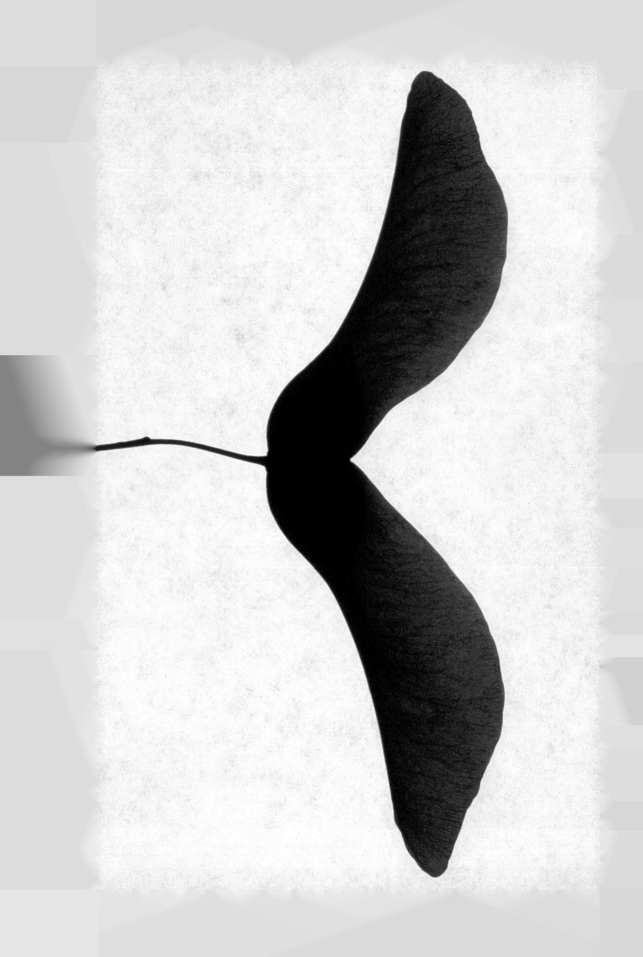

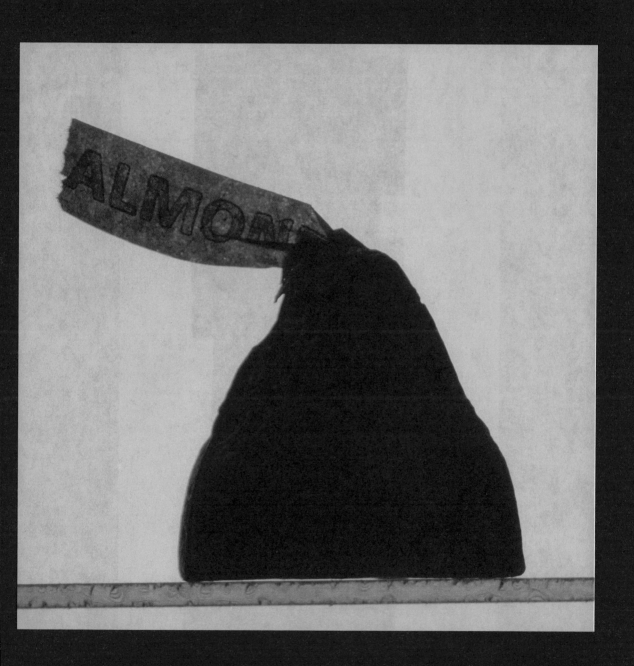

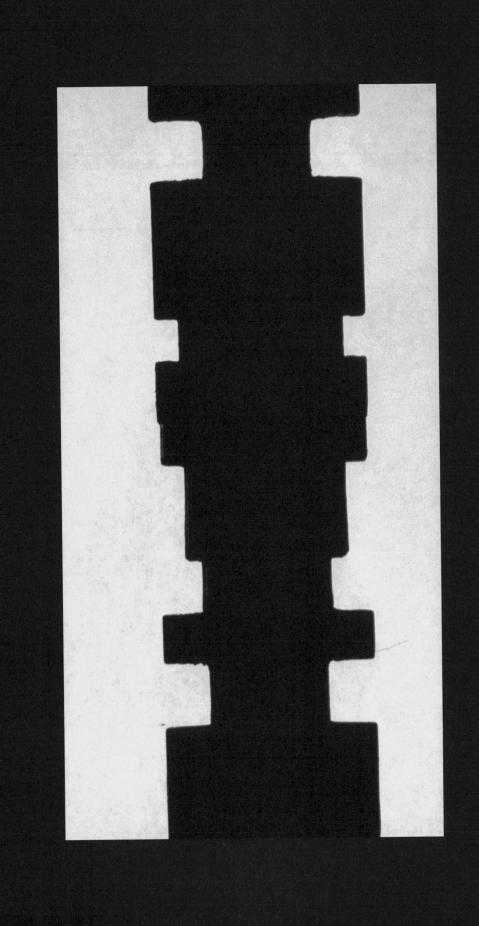

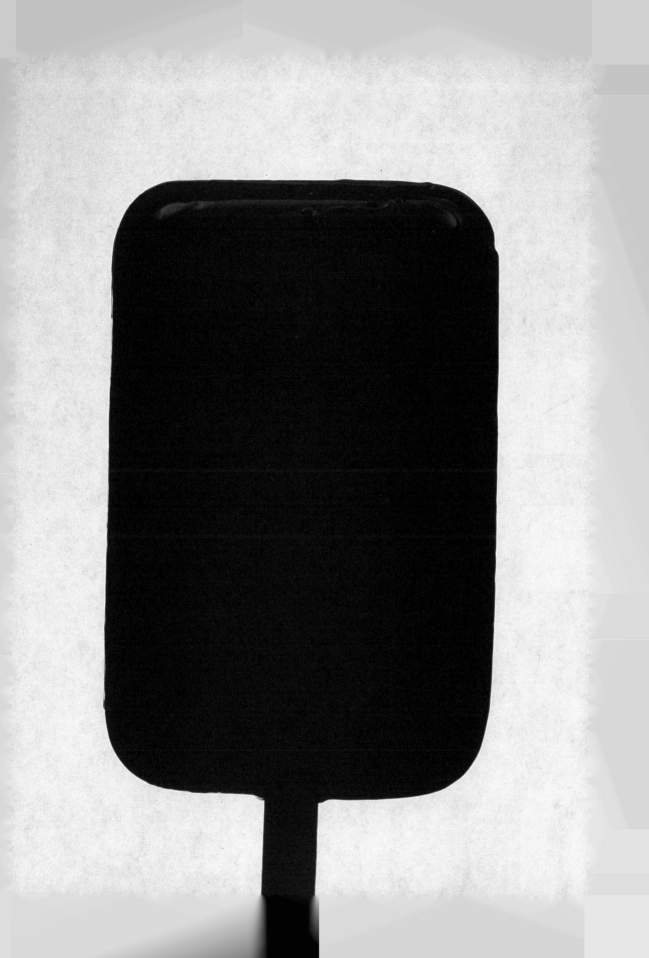

scissors

floppy disk

cracker

maple tree
seeds

chocolate
kiss

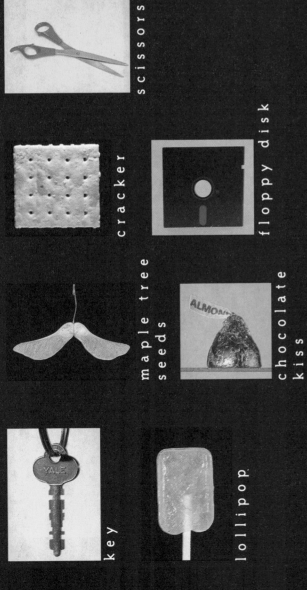

key

lollipop

Edges

We see and touch the edges of things all the time. But often we don't pay much attention to them. When the rest of the object is hidden, the edge of even a very familiar object can surprise us.

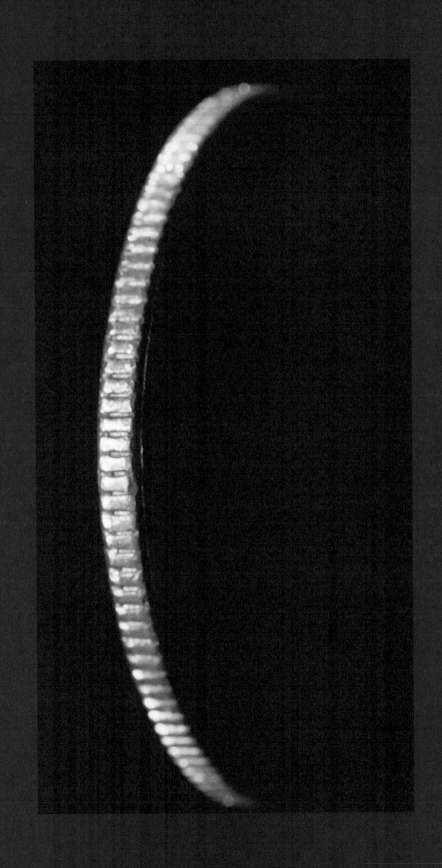

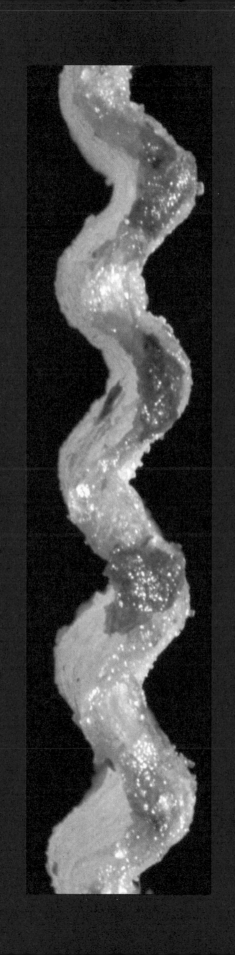

knife

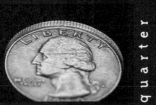

quarter

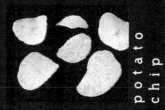

potato
chip